THE STREET ART
SKETCHBOOK

COLOR AND DRAW WITH GRAFFITI

PaRragon

Bath · New York · Cologne · Melbourne · Delhi
Hong Kong · Shenzhen · Singapore · Amsterdam

This edition published by Parragon Books Ltd in 2016
and distributed by

Parragon Inc.
440 Park Avenue South, 13th Floor
New York, NY 10016
www.parragon.com

Copyright © Parragon Books Ltd 2016

Designed by Talking Design
Illustrations by David Samuel
Written by Frances Prior-Reeves
Images and additional illustrations are courtesy of Istock and Shutterstock

ISBN 978-1-4748-1769-1

Printed in China

Although we as the publishers of this book have provided some photographs as backgrounds for you to design
and draw your own graffiti on those backgrounds, we would like to make it clear that we do not encourage any
act or form of vandalism, or any illegal activity relating to it, whether to public or private property or objects of
any kind. You will always need the express written consent from the owner(s); even then you should be aware
that creating graffiti may be an inherently dangerous activity which you carry out at your own risk.

To the fullest extent permitted by law, the author(s), photographer(s) and publisher: (i) cannot and do not
accept any legal duty of care or responsibility in relation to any actions expressed or implied by the contents of
this book; and (ii) disclaim any liability, loss, damage or risk that may be claimed or incurred as a consequence –
directly or indirectly – of the use and/or application of any of the contents of this book.

Introduction

Do you ever see a surface that could be improved by a graffiti tag, scribble, piece, or mural? Are you helpless to stop yourself doodling your ideas on anything within your reach? Then this book could be your salvation. Packed full of different surfaces and objects to perfect your graffiti skills on, you can personalize walls, trains, statues, and even the moon without getting into trouble or even leaving your home.

This is your sketchbook, so it's your rules. You can't get in trouble for letting your urban creativity run wild here. You can have fun, break the mould, and take inspiration from a multitude of items to embellish and help make the world a more colorful place. So unleash your inner street artist and enjoy the freedom this book allows when it comes to defacing, umm, enhancing, public property.

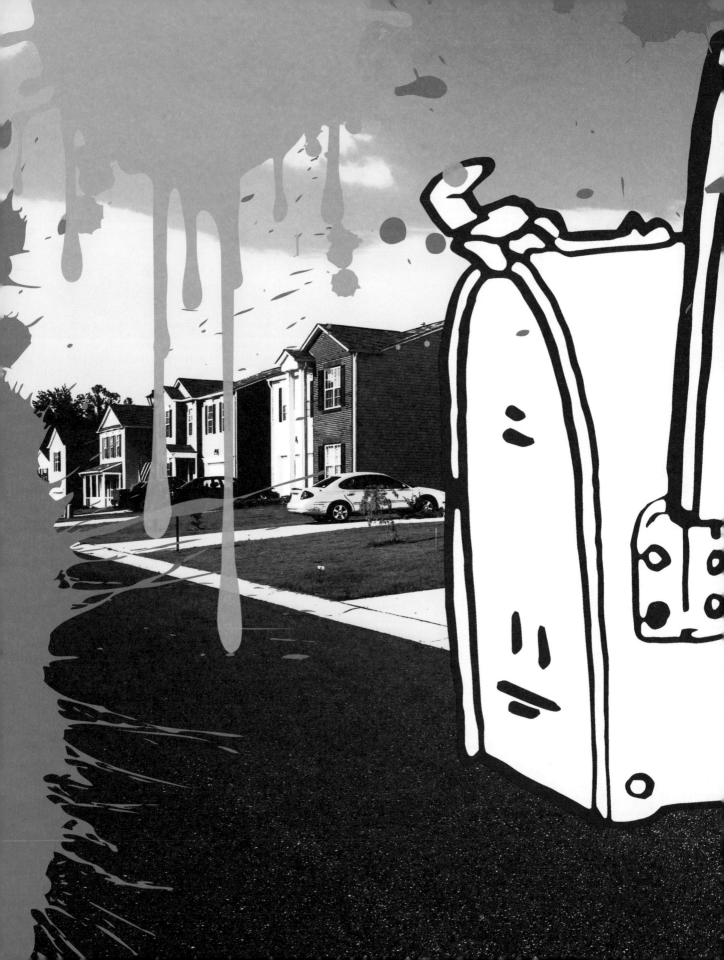

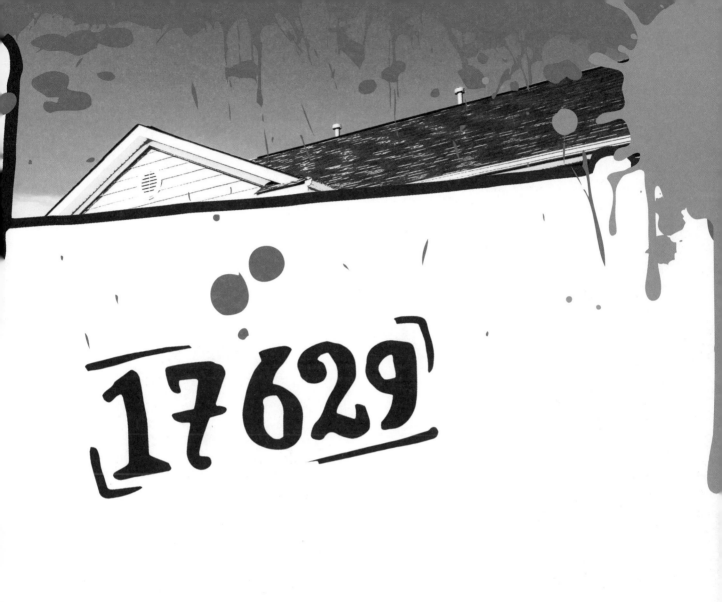

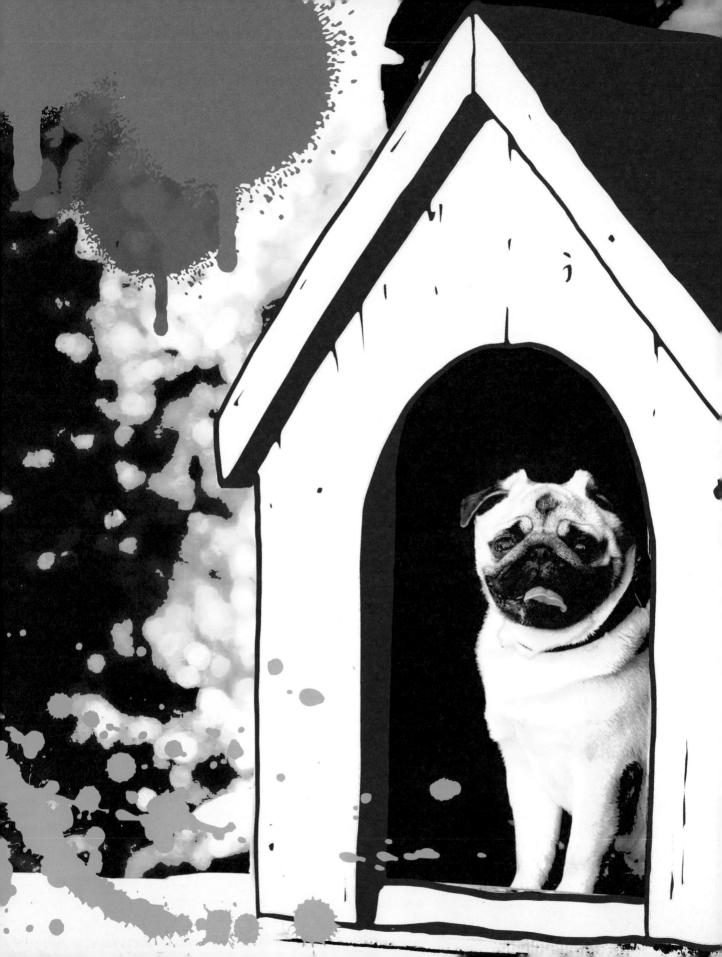

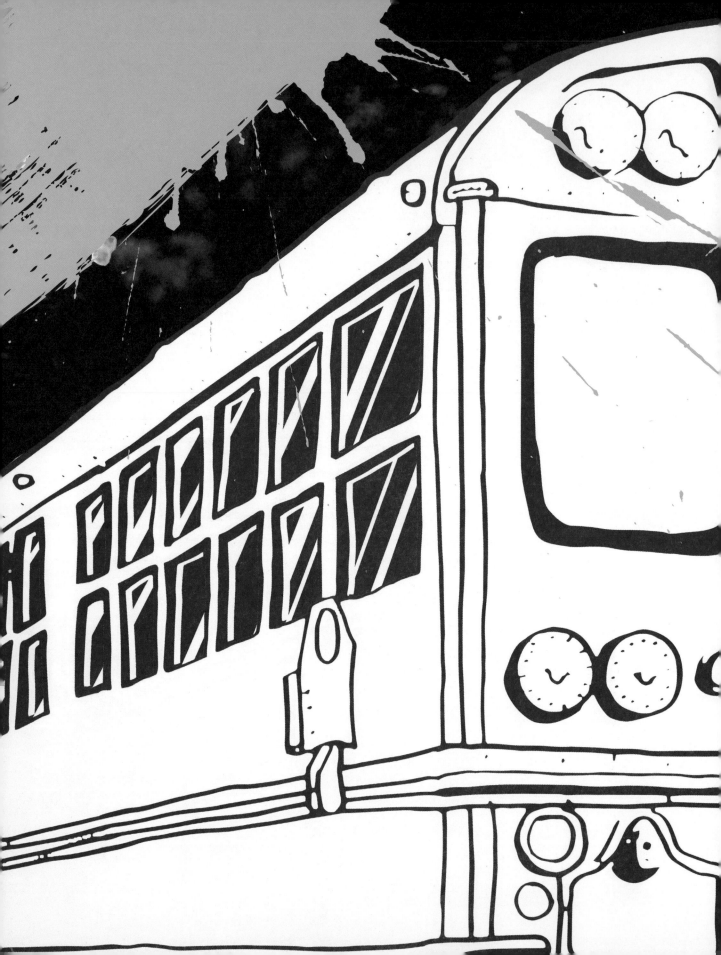

TAG THIS SCHOOL BUS

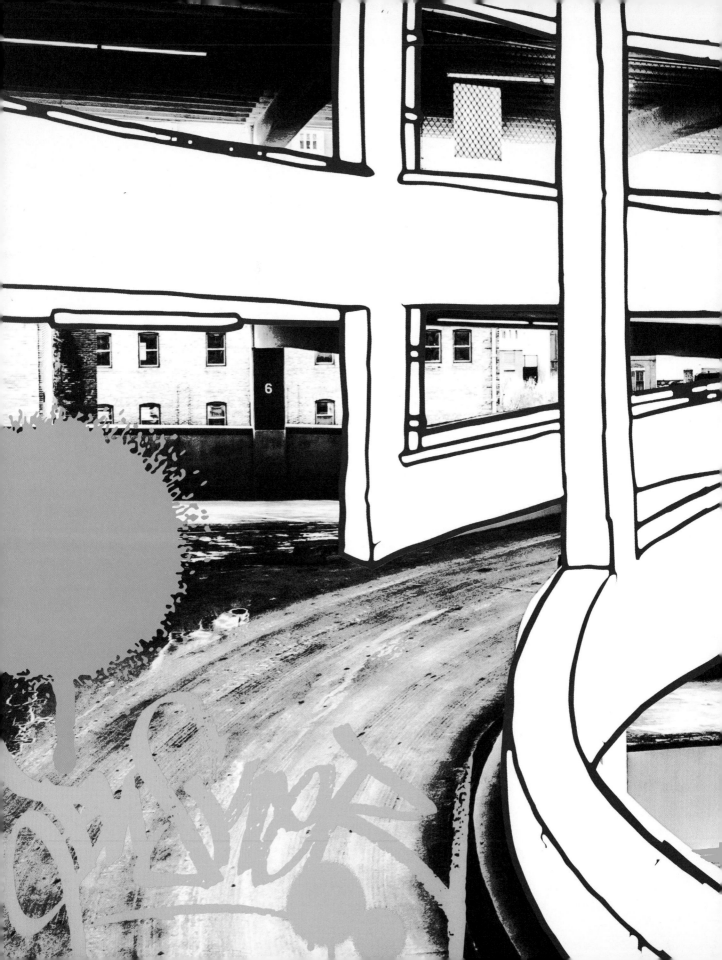

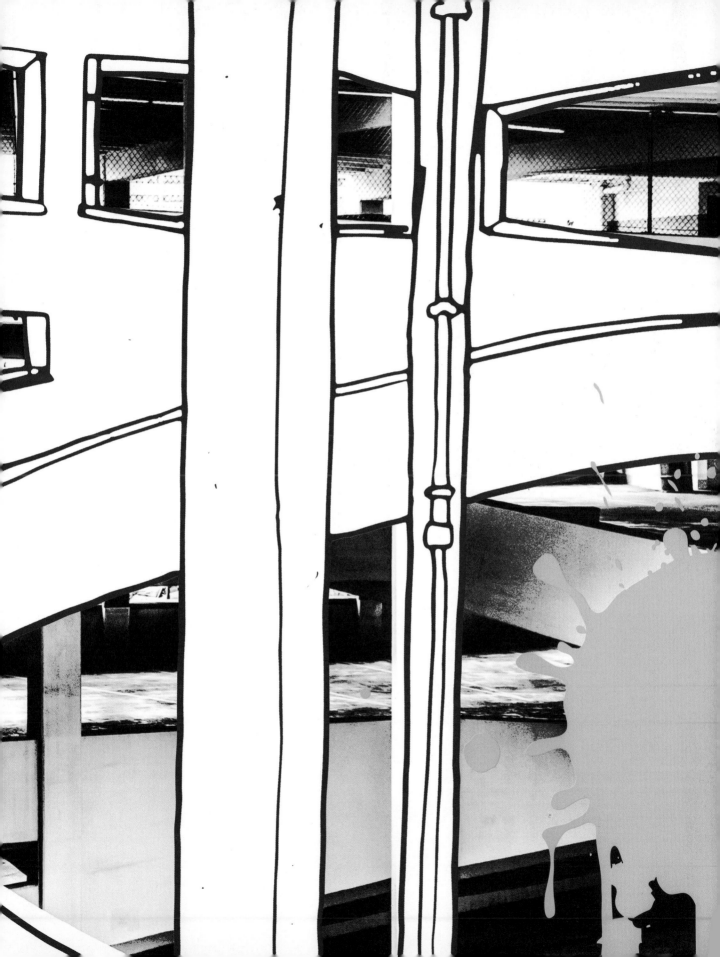

TAG THIS BILLBOARD

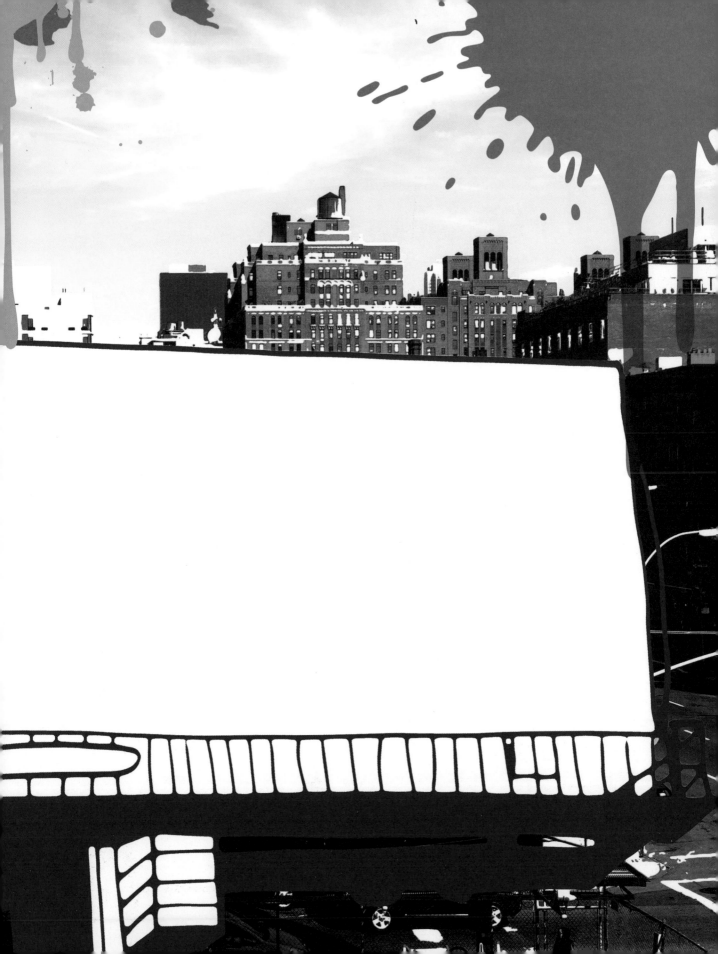

DEVELOP YOUR TAG

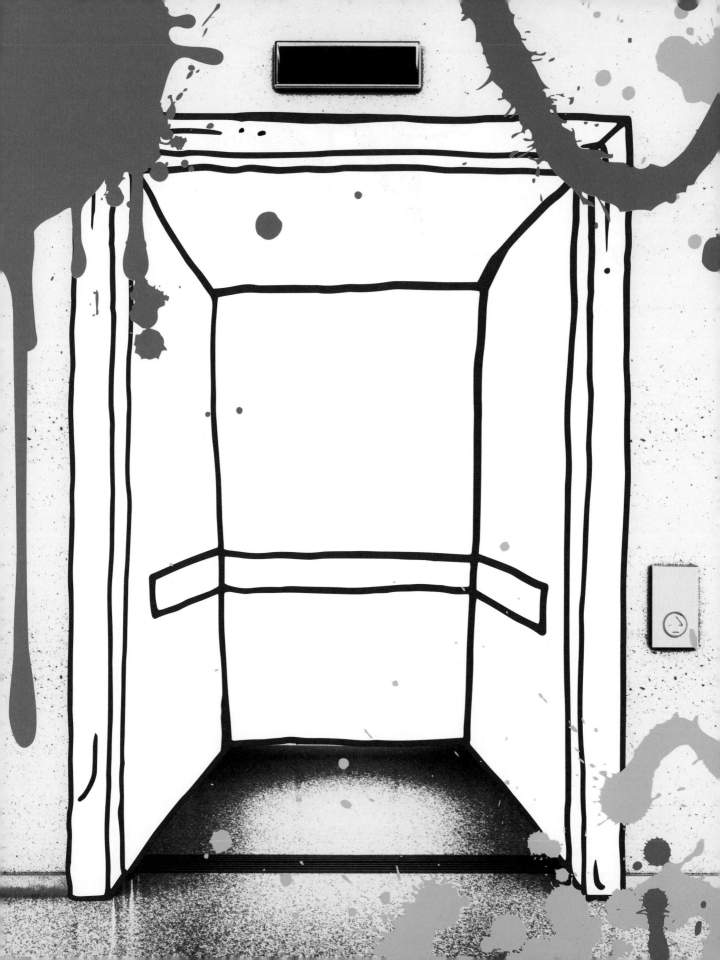

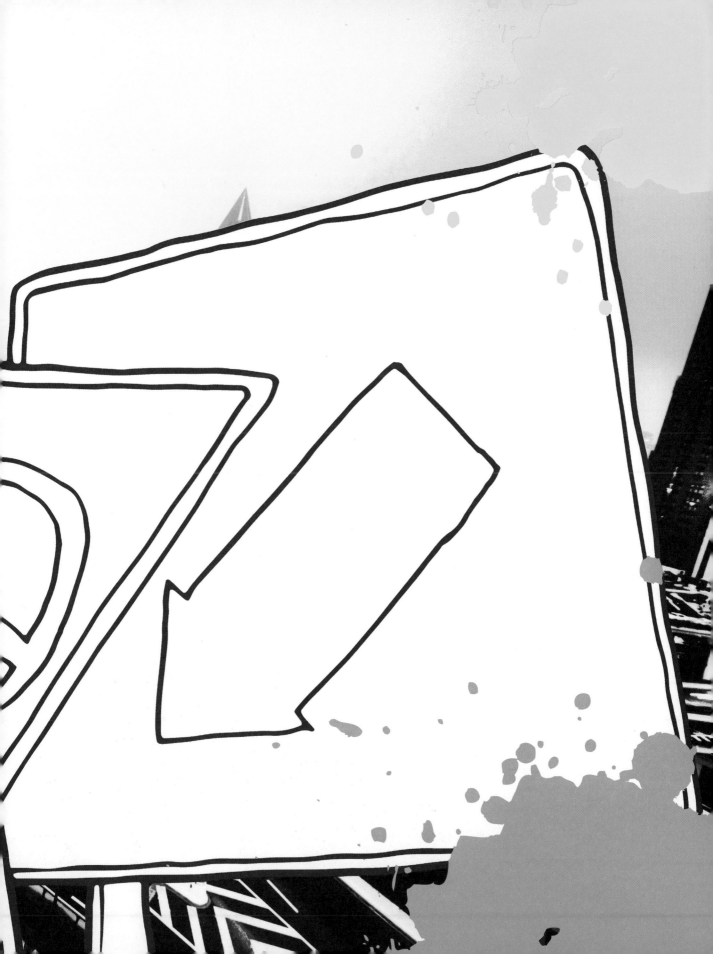

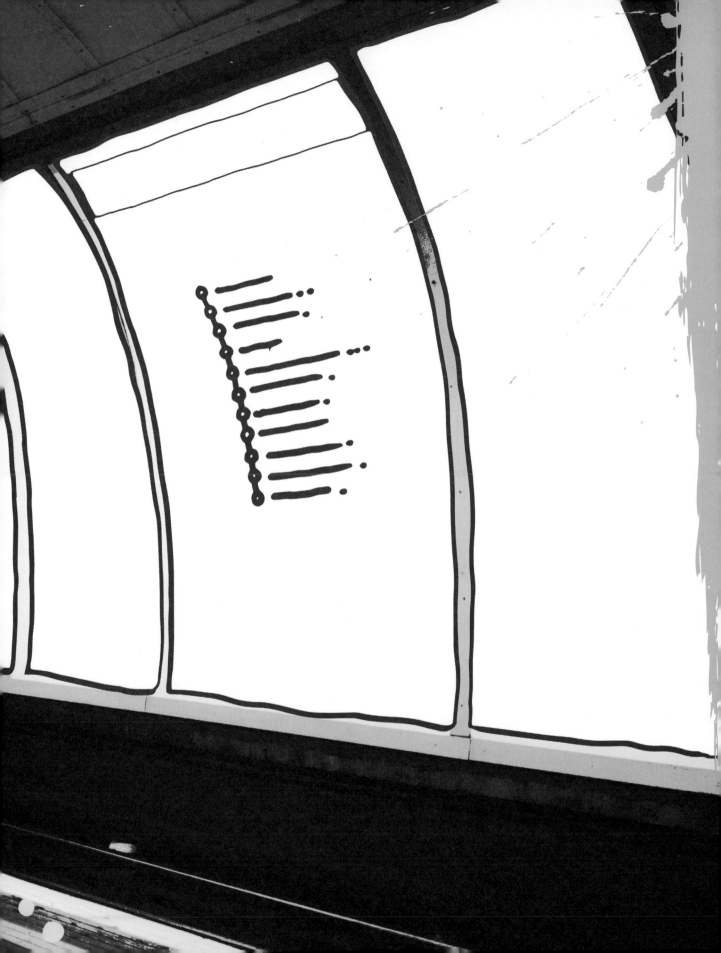

Repeat your design until there's **no space left**

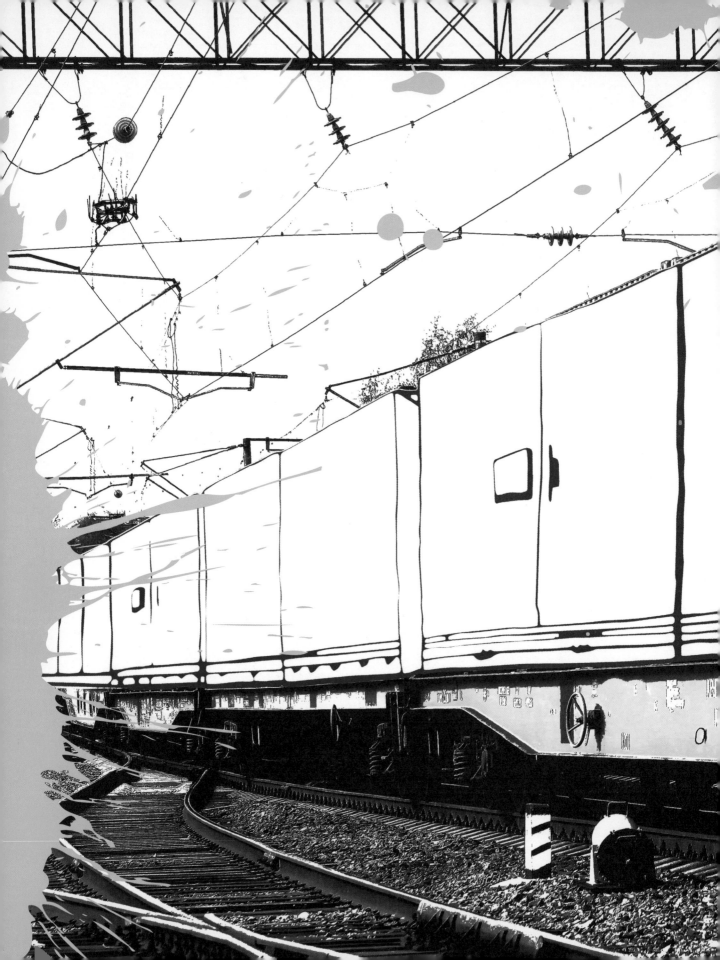

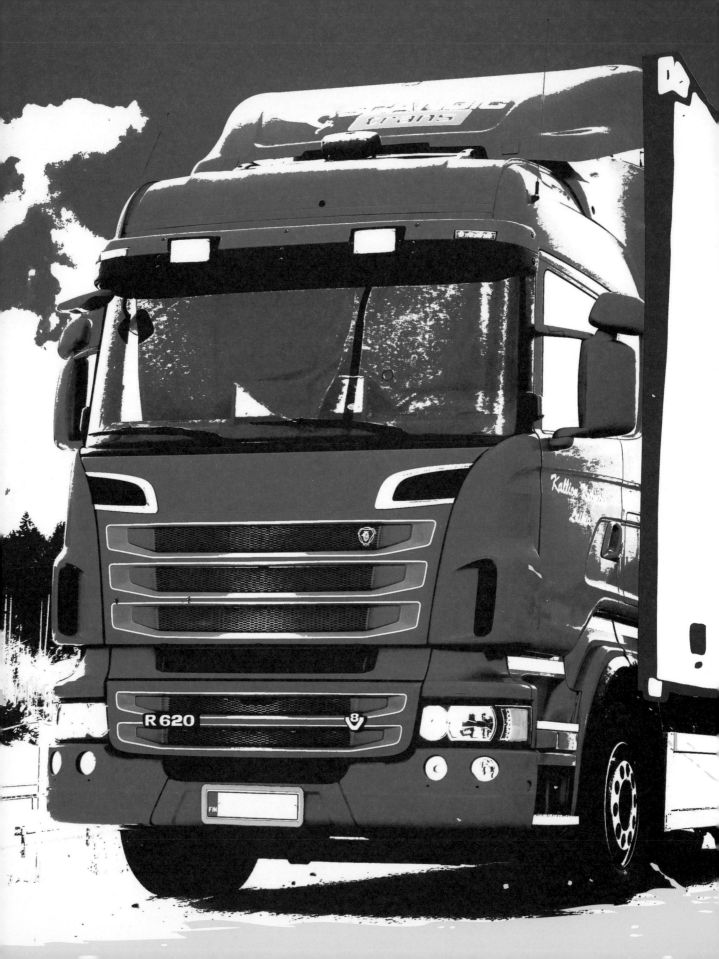

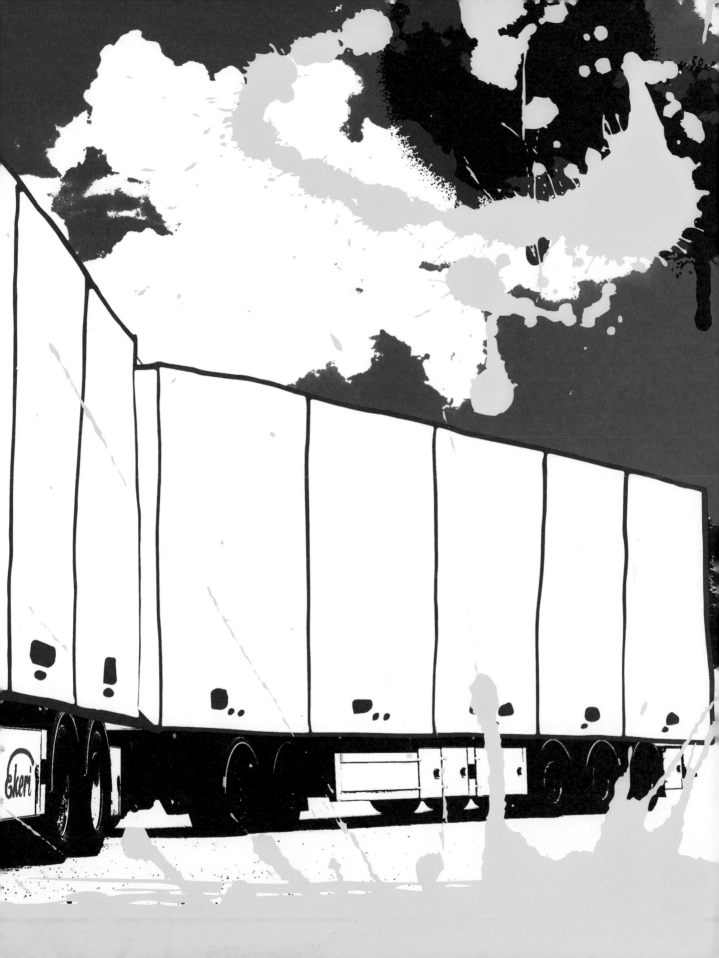

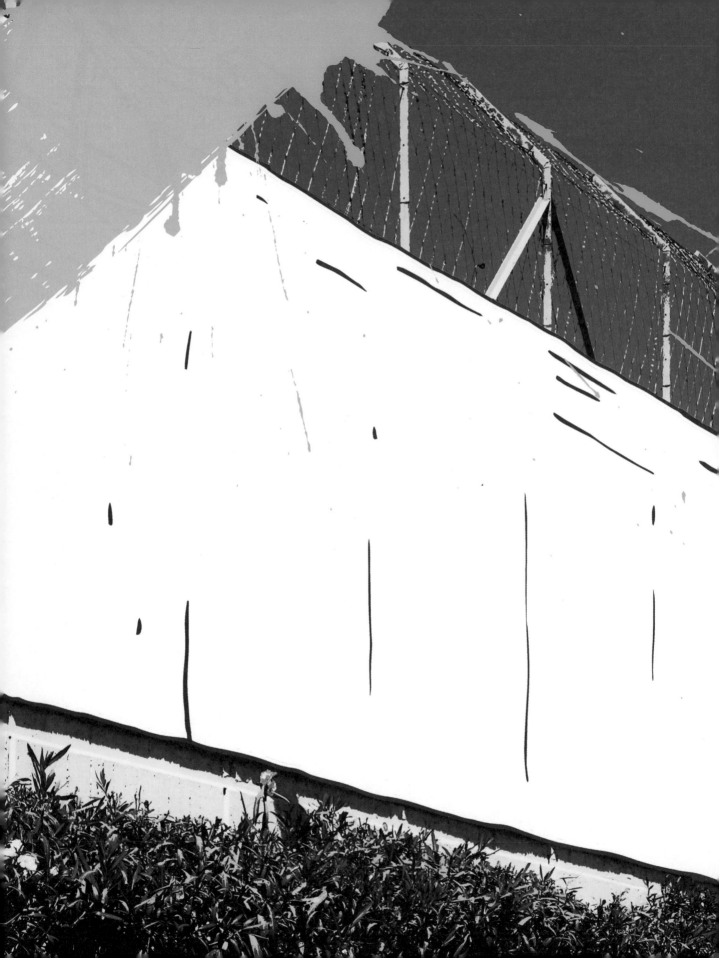

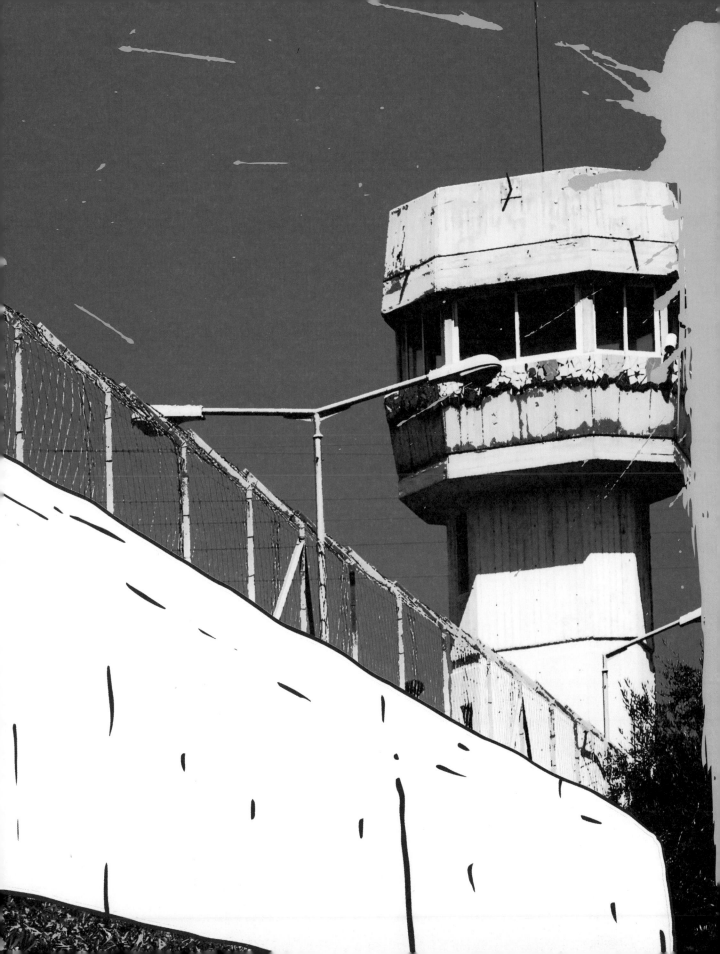

PERSONALIZE
THIS WALL

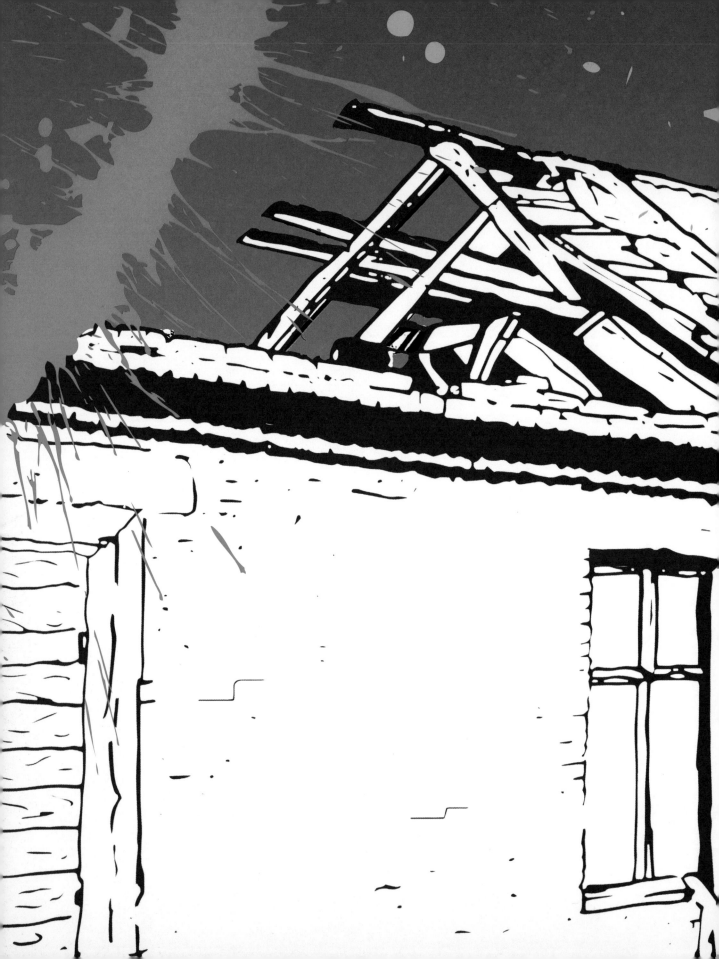

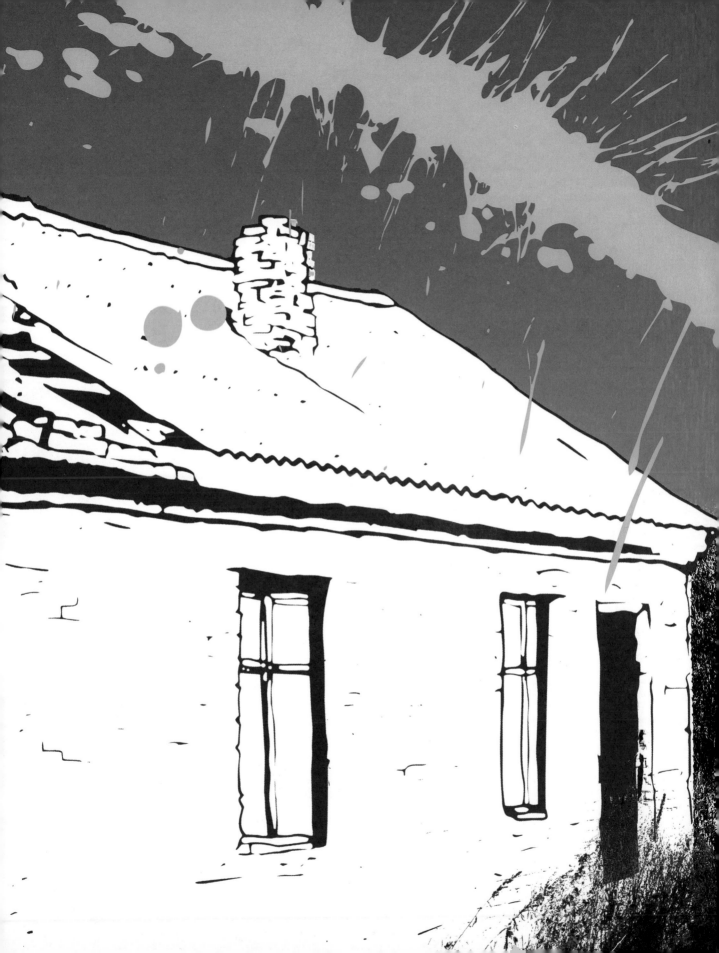

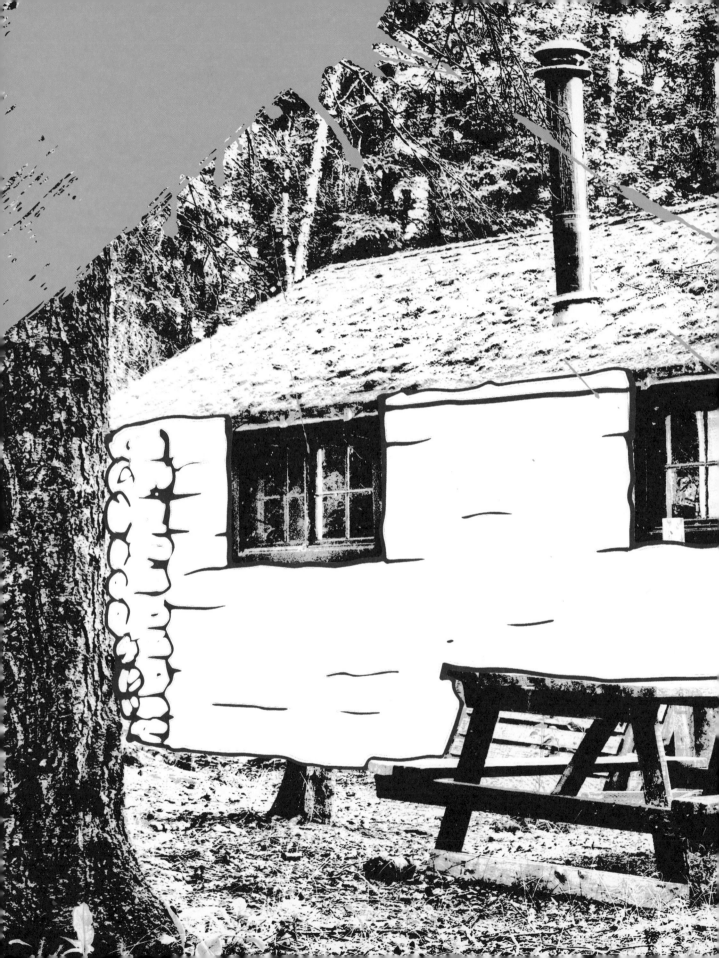

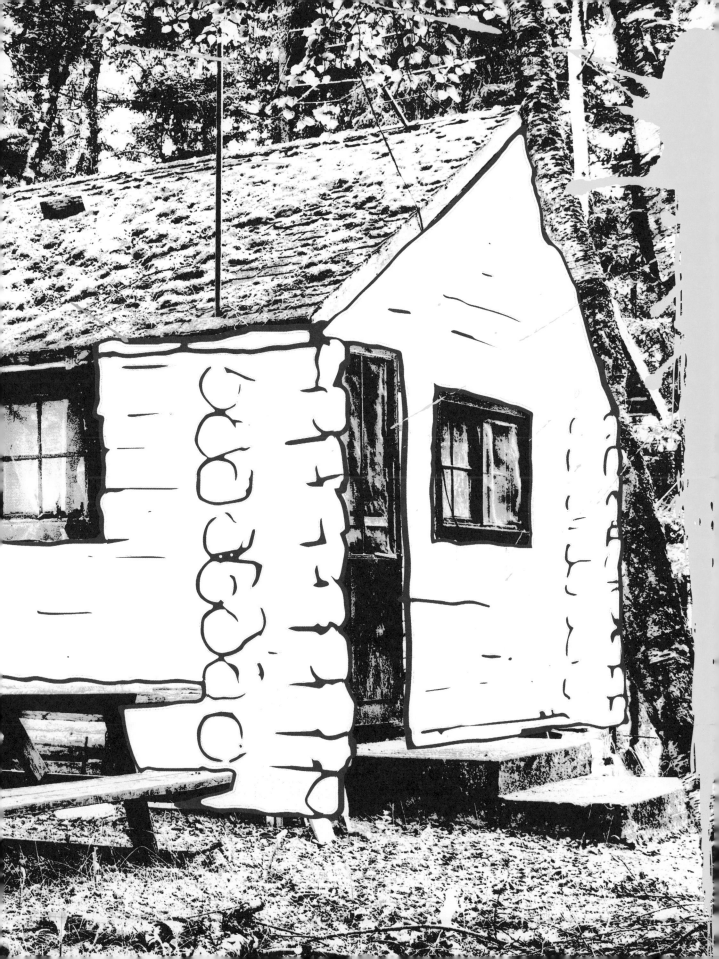

MAKE THIS SPACE
MEMORABLE

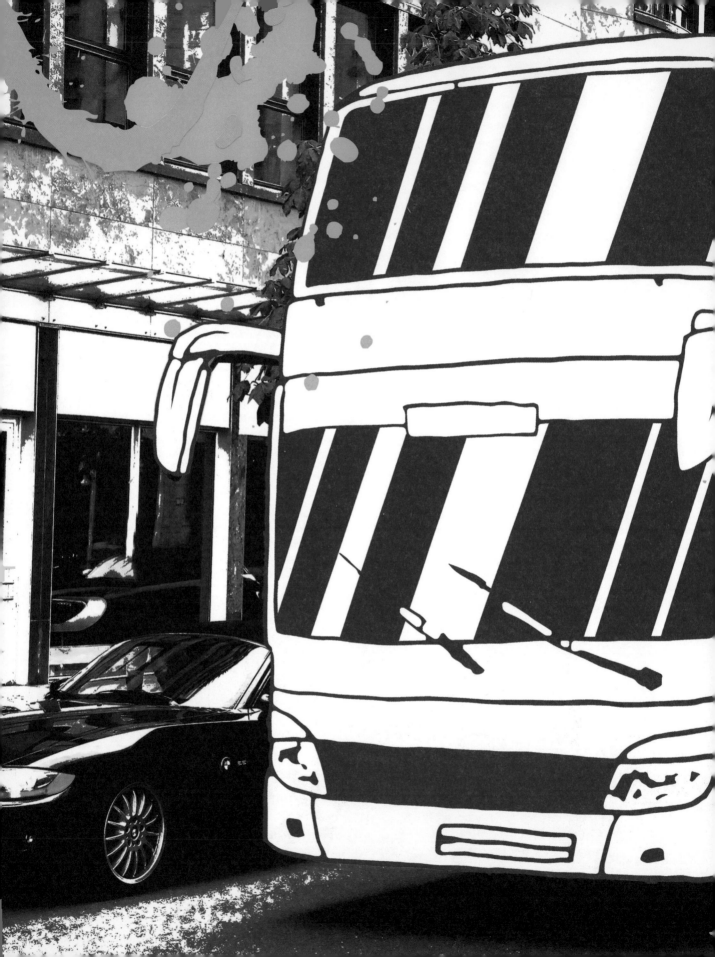

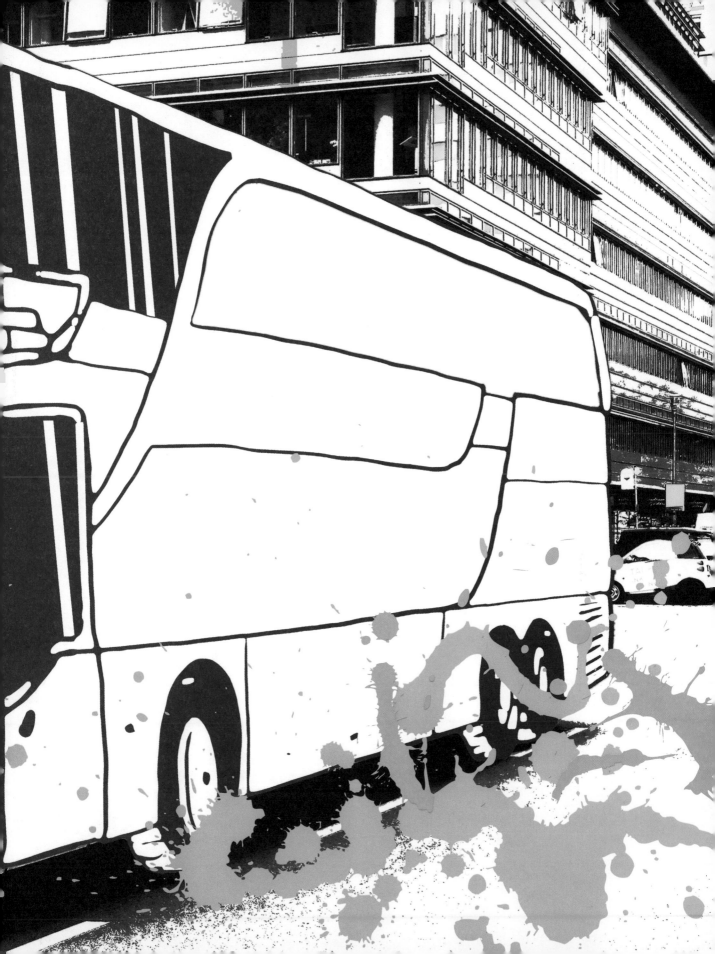

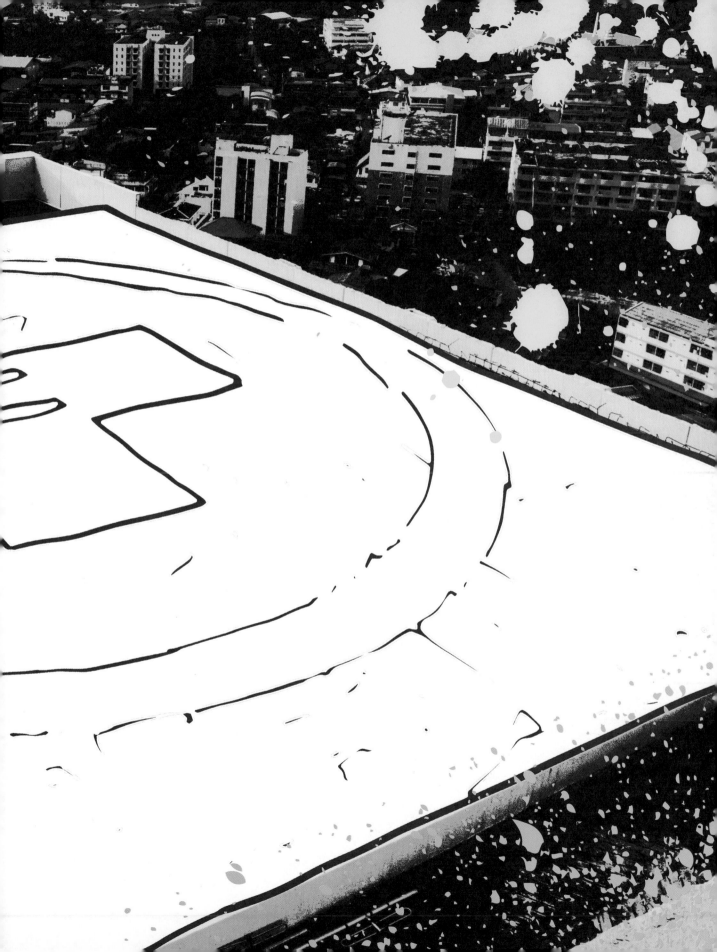

LIMIT
YOURSELF TO 2
COLORS

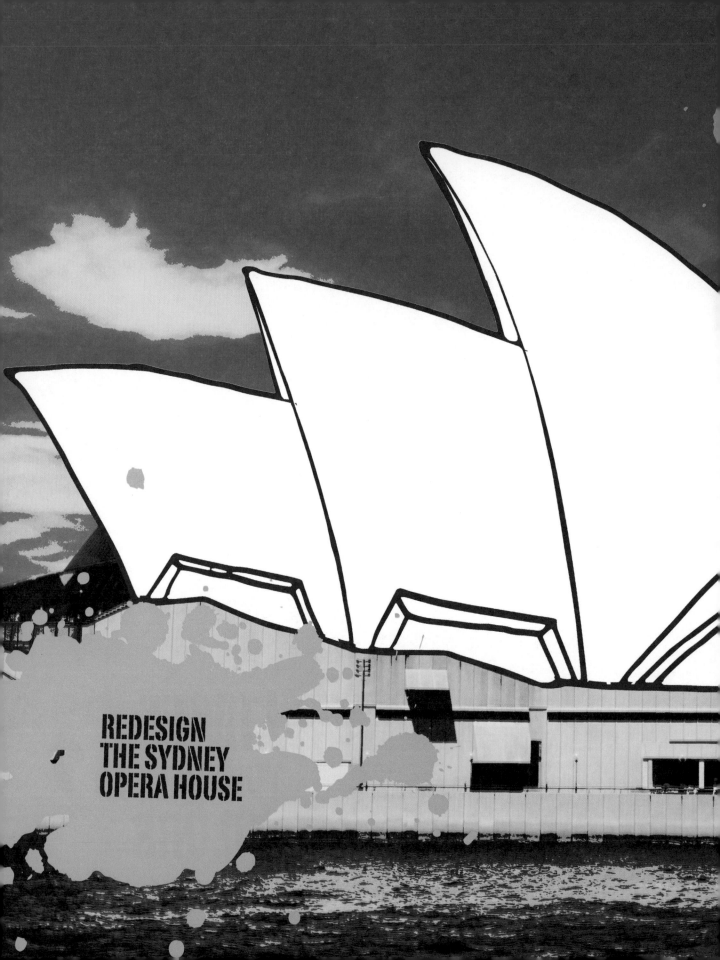

REDESIGN
THE SYDNEY
OPERA HOUSE

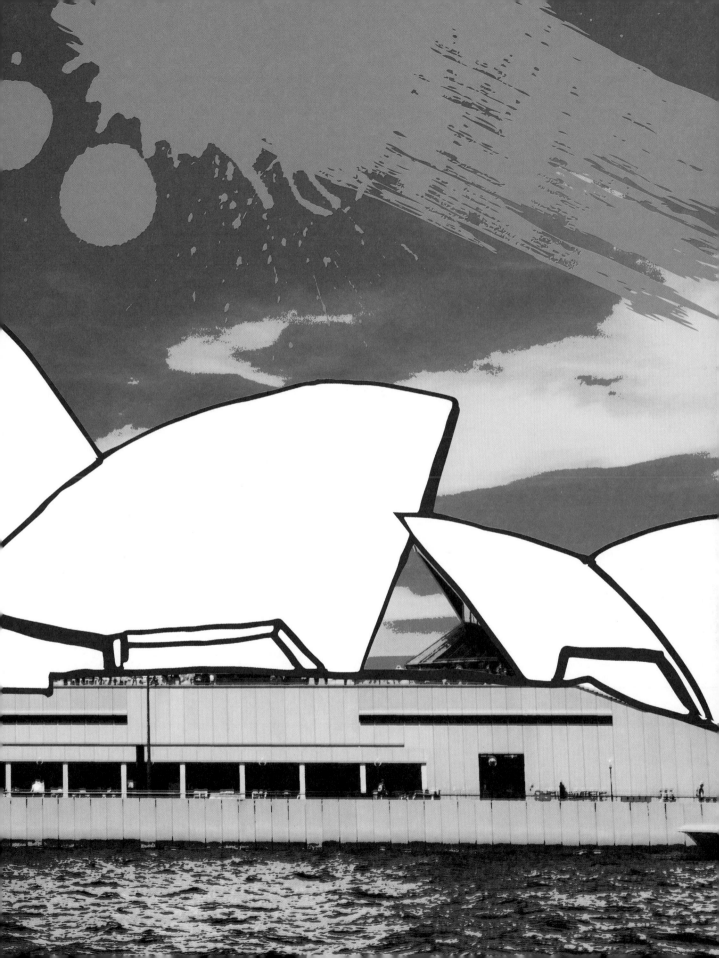

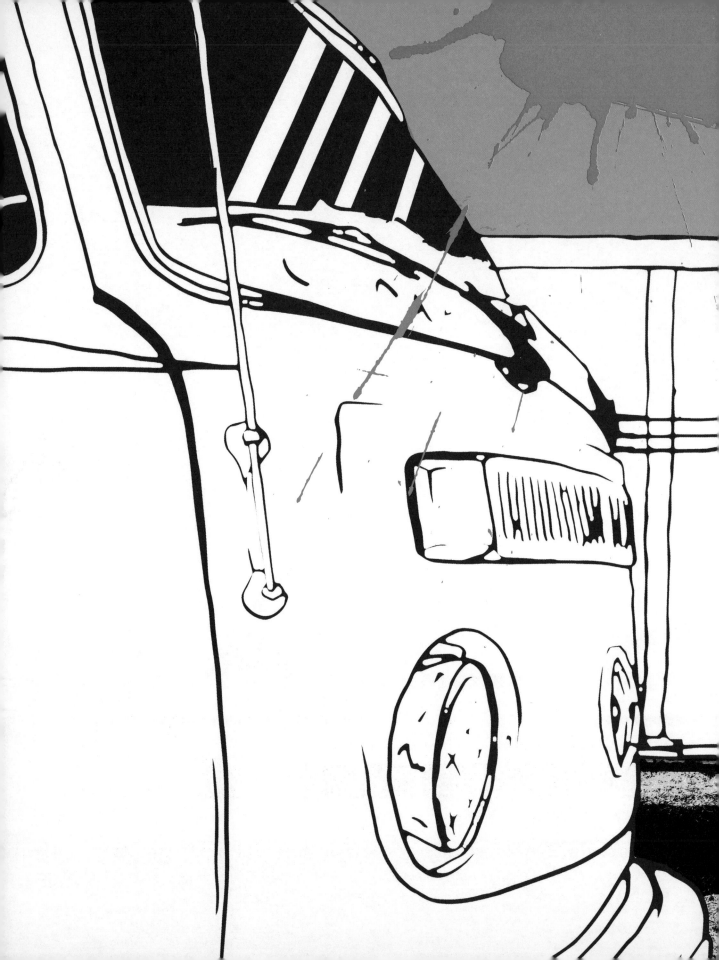

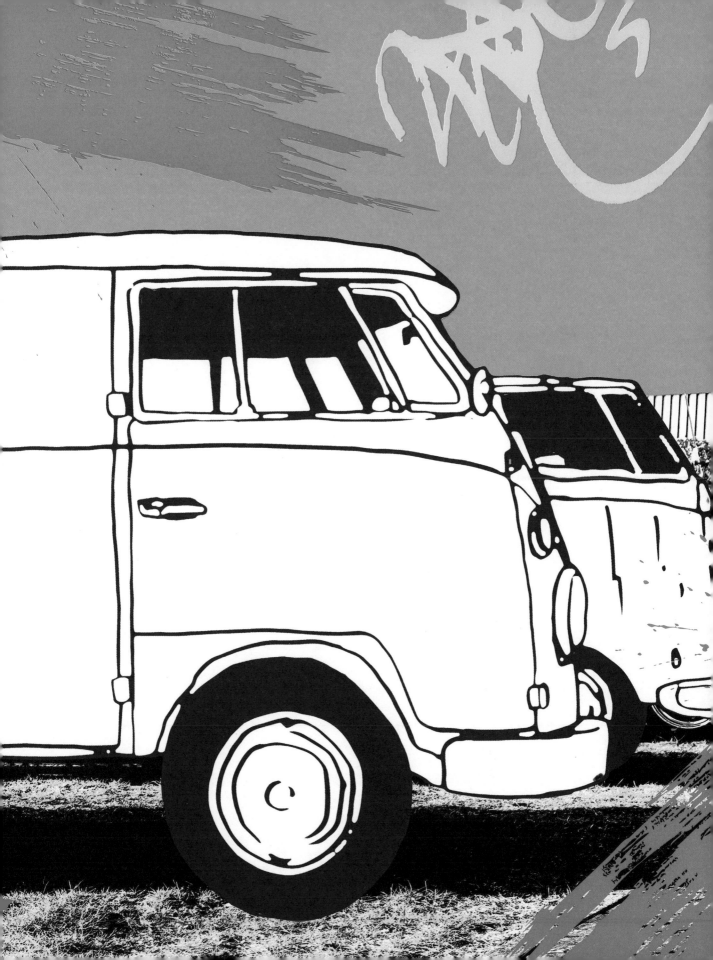

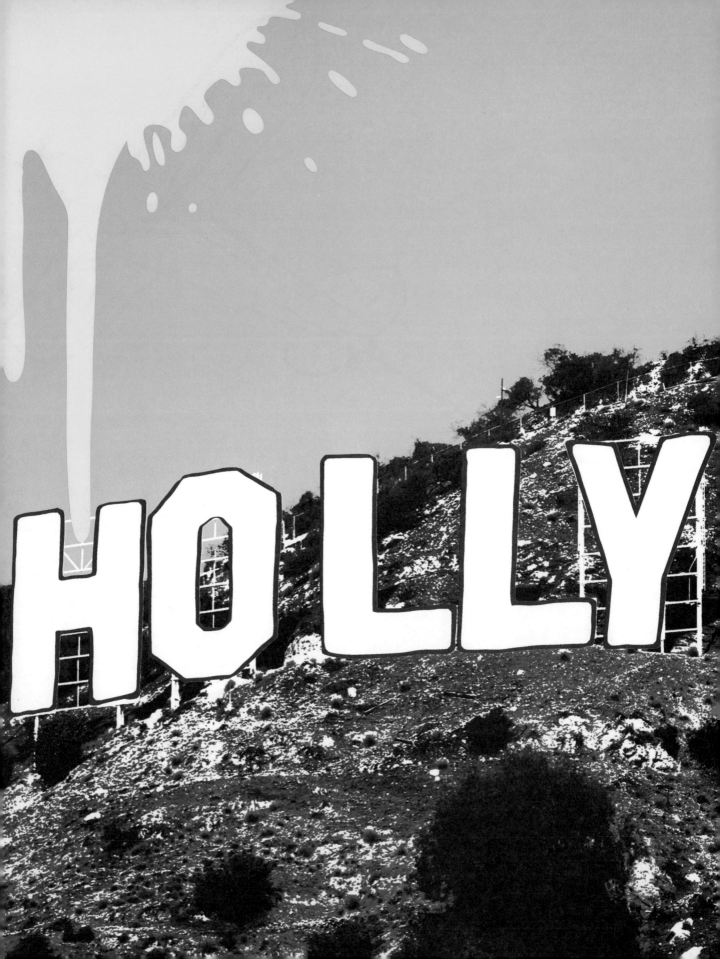

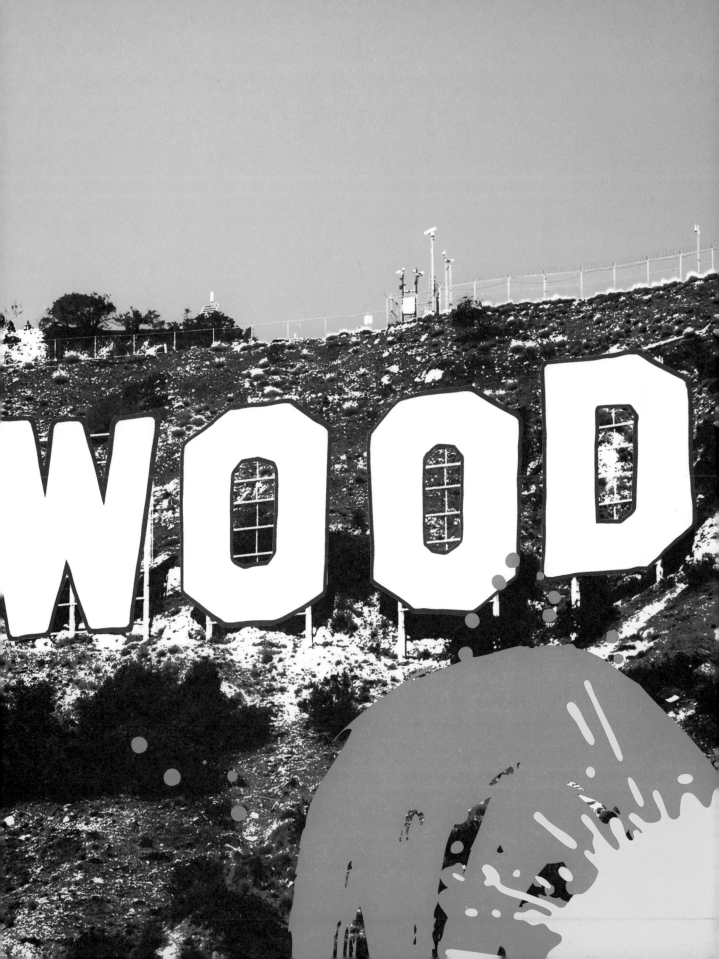

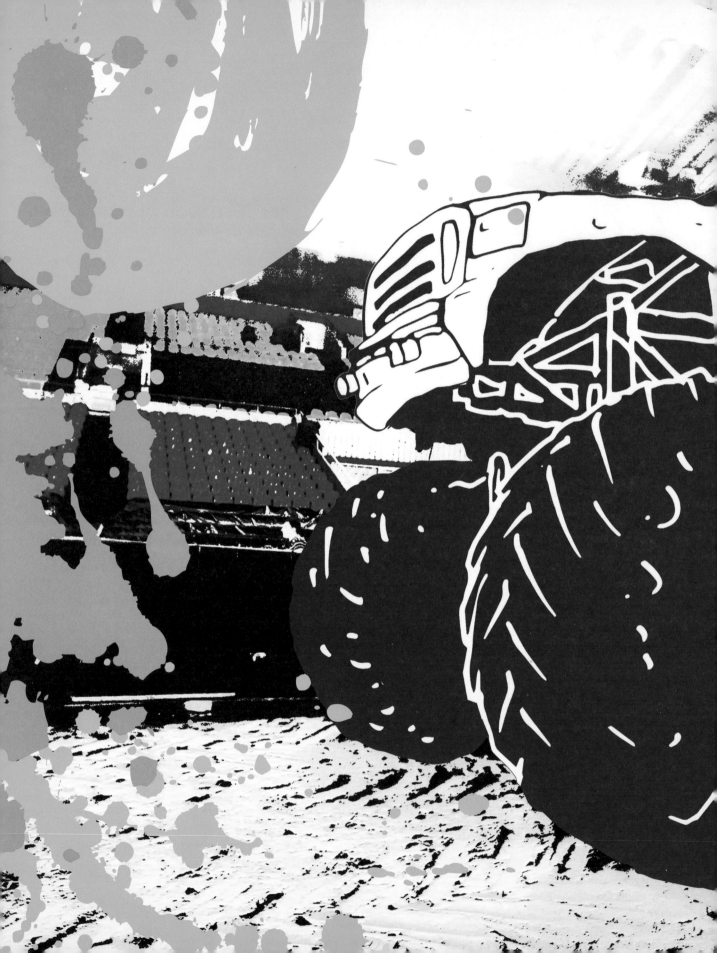

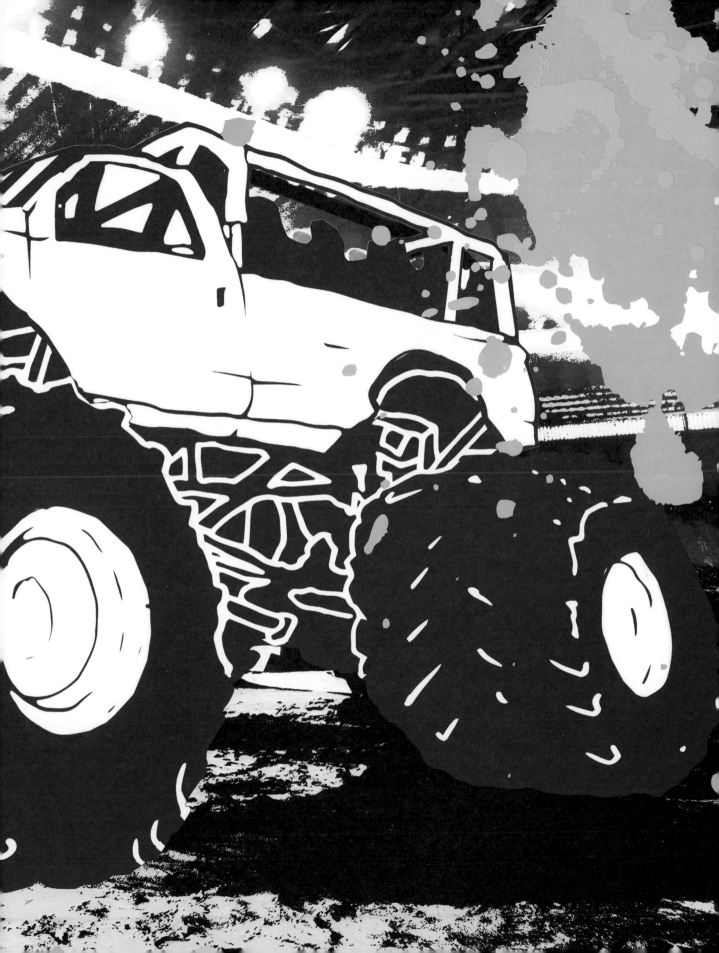

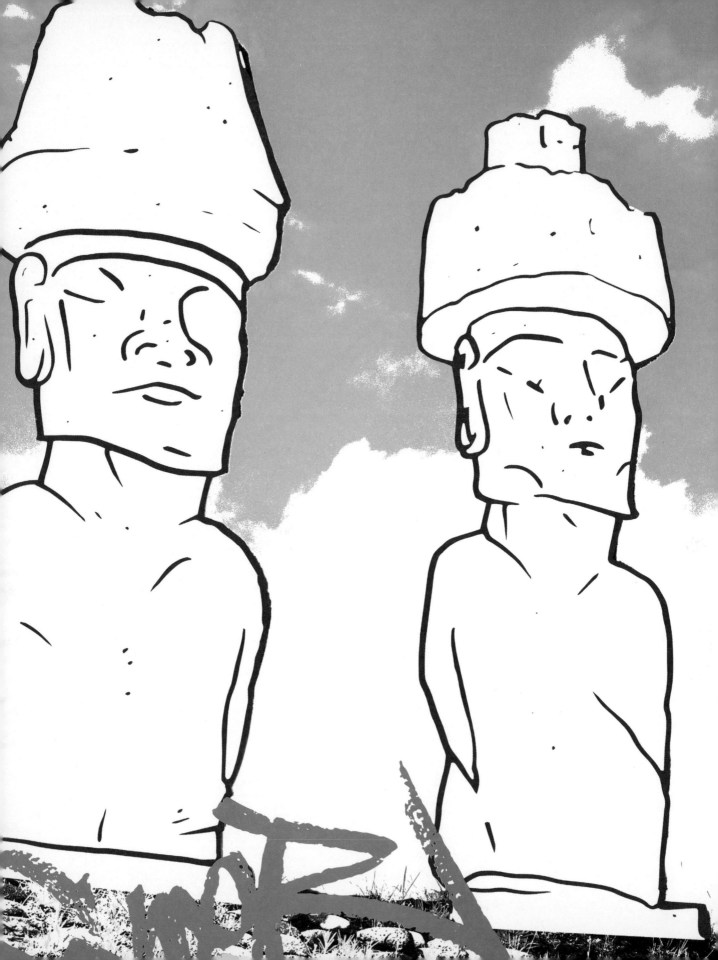

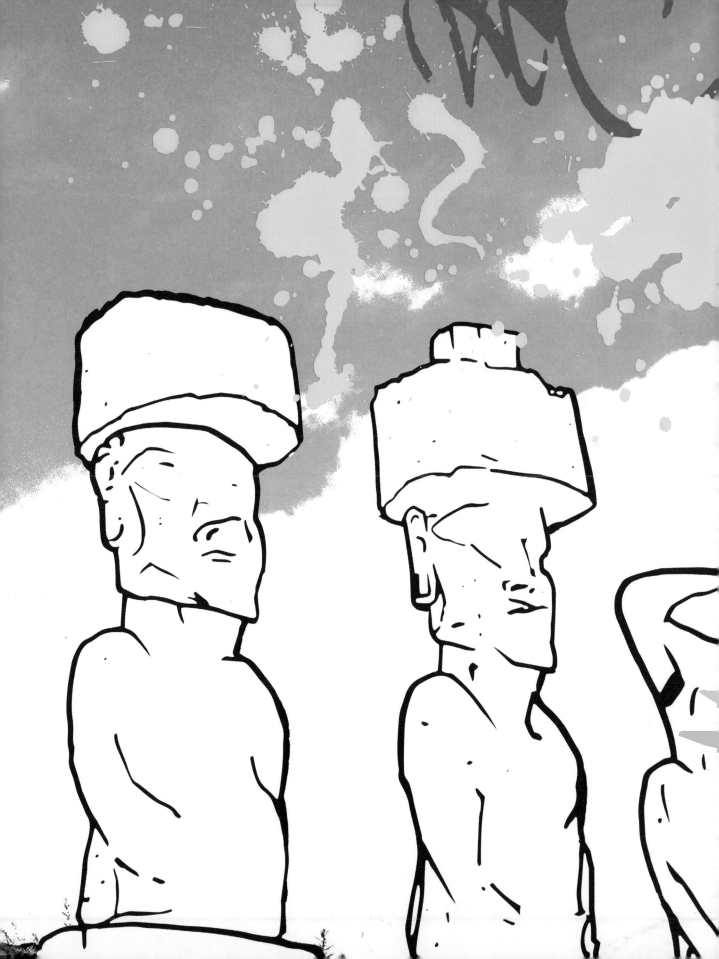

GRAFFITI OVER A
MASTERPIECE

ESTABLISH YOUR STYLE

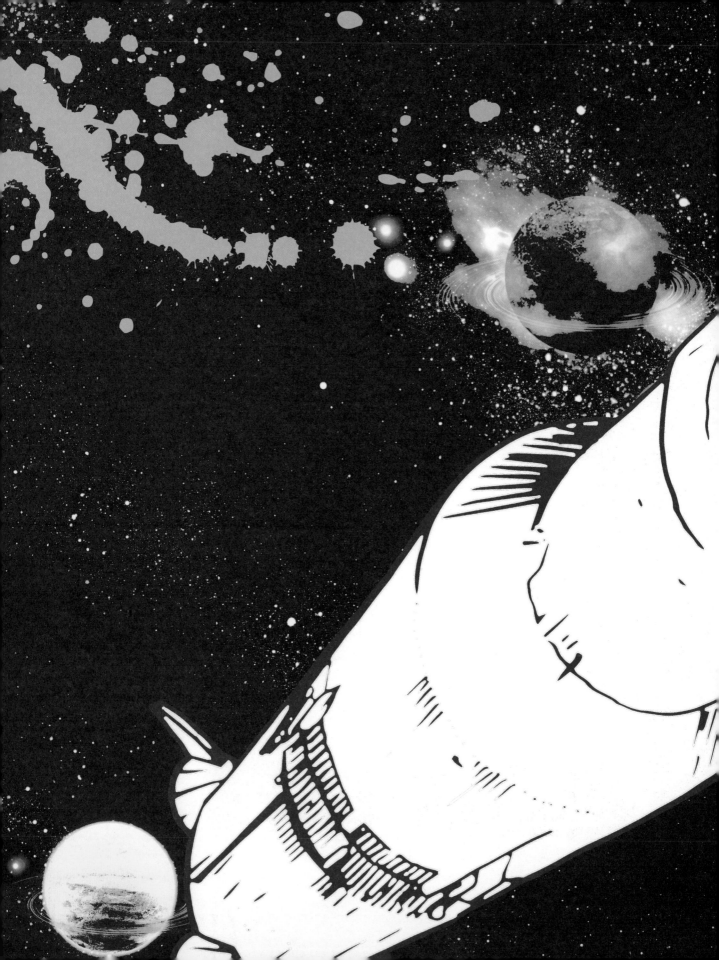

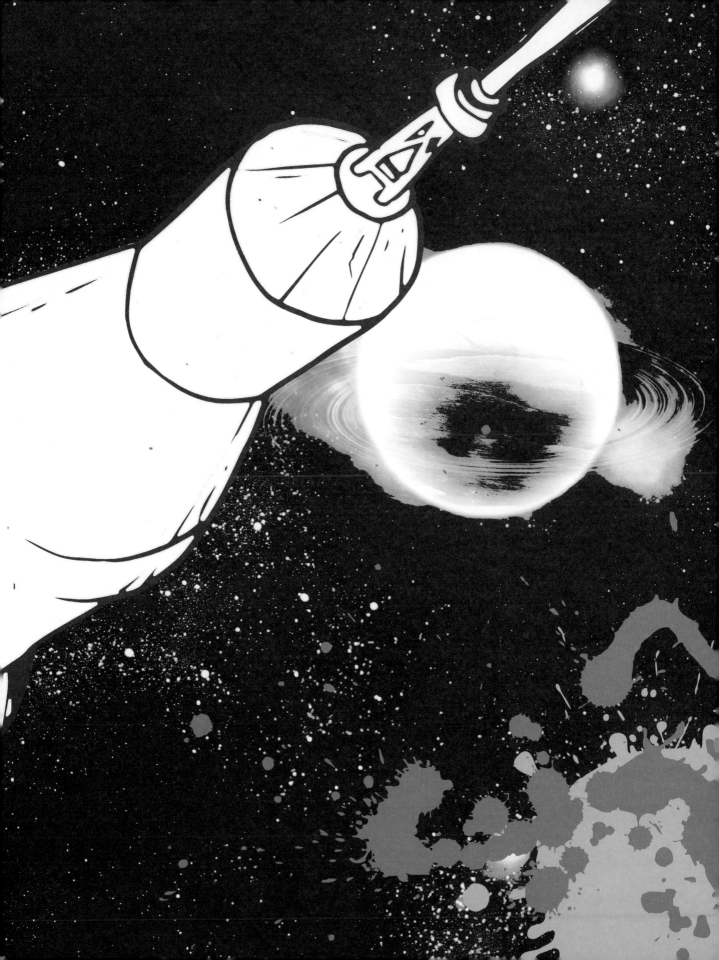

Be the first to tag the **moon**

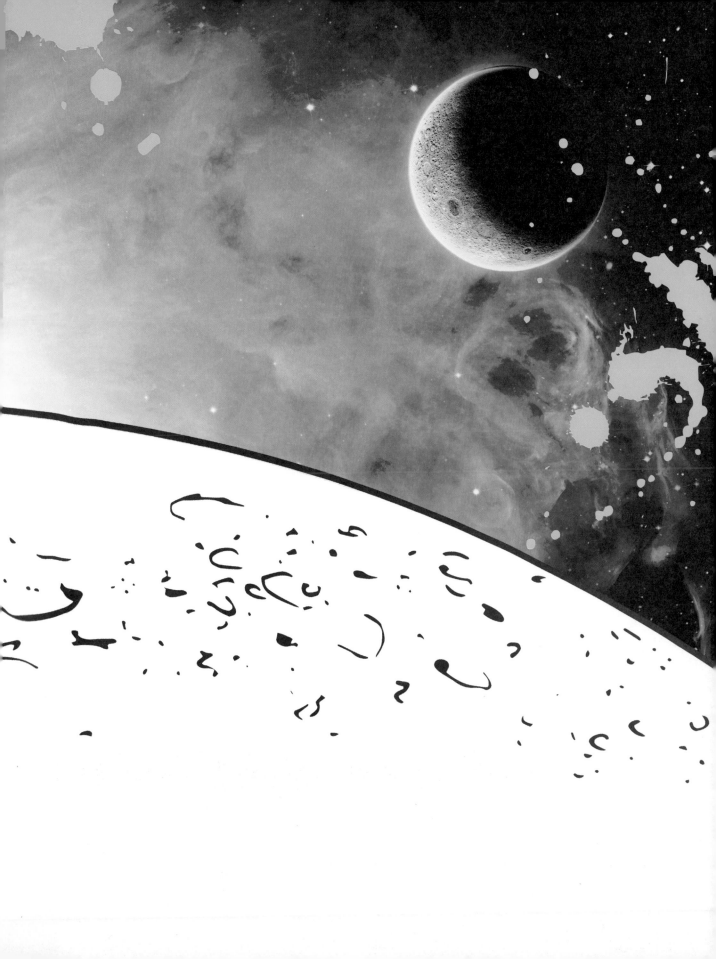

MAKE THE
WORLD A MORE
COLORFUL
PLACE